drawing

Improve Your Painting and Drawing

Fountain Art Series. Fountain Press London

Available from:
INTERNATIONAL PUBLICATIONS SERVICE
COLLINGS, INC.
114 East 32nd Street
NEW YORK, N. Y. 10016

. Parramon

wing

Fountain Press Limited
46/47 Chancery Lane
London WC2AIJU

First Edition in English, 1971
Original title in spanish
«Así se dibuja»
© José M.ª Parramón Vilasaló

Available from:
INTERNATIONAL PUBLICATIONS SERVICE
COLLINGS, INC.
114 East 32nd Street
NEW YORK, N.Y. 10016

ISBN 0 852 42086 2

Printed in Spain by
Lito-Pisa, S/A, Jaime Piquet, 7 - Barcelona
Depósito Legal B- 31.759 -- 1971
Número de Registro Editorial 785

CONTENTS

How to measure and relate accurately

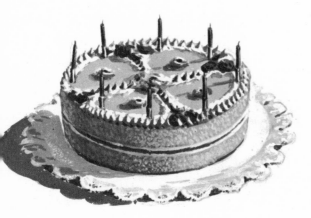

BIRTHDAY CAKE

Without wishing to boast, I am the «official cutter» of all the cakes and pies we have at home. I have, it seems, a good eye and, whenever there is some special occasion, my wife asks «Will you cut?»

«How many are we?»

Conversation usually ceases abruptly at this stage and my three children exchange glances. Perhaps the problems of population density and of supply and demand are already beginning to formulate in their young minds.

Julia, the eldest, counts. Her grandfather daydreams while Philip, the youngest, is already trying to work out the height, width and volume of his slice of cake.

«Six» announces Julia.

«Right. That means we must start by dividing the cake into three ... like that ... and then cut each piece in half ... like that. There!» I say.

There is no particular merit in being the family's official cake cutter. It has come about as a result of my having spent most of my life cutting cakes or, more specifically, calculating dimensions by eye, «boxing up» by eye and comparing proportions by eye. This is something that I, like

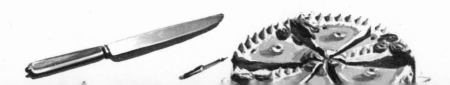

all professional draughtsmen, do every day. I suppose one might say that the person who can most accurately divide a cake is the one most likely to be able to do the best drawing.

«Daddy, how do you manage to make all the pieces the same size?» asks Catherine.

How indeed? The subject of sight training is one which no author has really tackled seriously. Well, no, that's not quite true: five hundred years ago that great master Leonardo da Vinci dealt with the question in his «Treatise on painting». What insight he had when he said:

«*Exercise your eyes and learn to see the true length and breadth of objects. And, to accustom your spirit, let one of you draw a straight line on the wall with a chalk and the rest of you try to calculate its length from a distance of ten paces. Then measure the line and the one who has calculated its length most closely is the winner. All these games are useful in the formation of judgement by sight, which is the principal factor in drawing and painting.*»

«The principal factor in drawing and painting»

I well remember how, when I first started drawing, I knew nothing of this «judgement by sight» of which Leonardo spoke. I too had sat in front of my subject staring at a sheet of blank paper, without any idea where to begin. I had heard about boxing up and been told «Begin by thinking of all the main parts of the drawing as if they were blocks; put these into boxes and, from here, start forming the parts». But I still wondered where to begin, how to draw the boxes and what size to make them. I felt sure something must precede the boxing up stage, that there must be some way of breaking through the «white paper barrier».

After a time I discovered that what was missing was the mental calculation of dimensions. I then found that the second problem lay in knowing how to increase and reduce these dimensions without altering the relationships between them. It was not until some time later that I learnt how to put the theory of boxing up into practice.

STAGE ONE: THE MENTAL CALCULATION OF DIMENSIONS

«Look, there's a man going to do some drawing — obviously a professional artist. Shall we go and watch him?»

Carrying his portfolio and stool under his arm, he walks slowly along the village street to his selected place, the façade of an old house (see illustration opposite). When he reaches it he stands in front of it for a full five minutes, gazing at it fixedly.

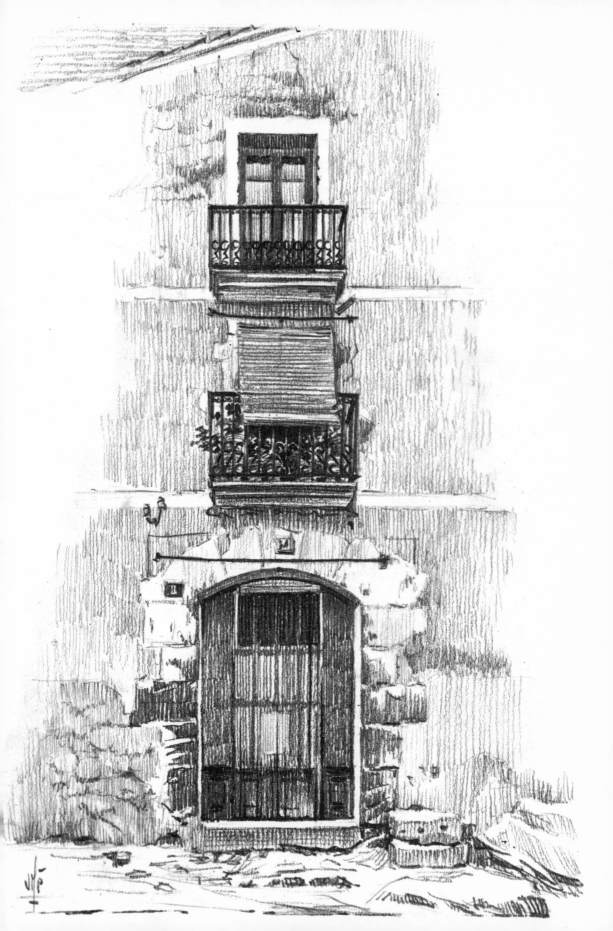

Then, still gazing at his subject, he opens his portfolio, sets up his stool and sits down. Two small boys wander up to him, waiting for him to take something out of his portfolio. «But he's not painting anything», says one of them, obviously implying that he must be mad. The artist, however, doesn't hear them he is completly absorbed in his subject.

Now, still looking at the balcony, he half closes his left eye, as if trying to remember something.

Then, suddenly, he seems to come to life. He takes out a sheet of white paper, fixes it in place and chooses a pencil from a collection in his pocket. Then, and only then, does he catch sight of the two boys. «Well, do you like drawing?» he asks.

He looks the paper up and down, as though tracing outlines in his mind's eye, then raises his head and looks back at his subject, his gaze caressing all the nooks and crannies in the doorway, the ironwork, the blinds and the balconies.

What is he doing? He is calculating. Calculating, mentally, «the true length and breadth of objects», as Leonardo put it. He is comparing certain distances with others, looking for reference points to carry basic lines, drawing imaginary lines in order to determine the position of certain objects in relation to others.

This is the mental calculation of dimensions. In order to establish it as a basic rule, let me repeat that it consists of:

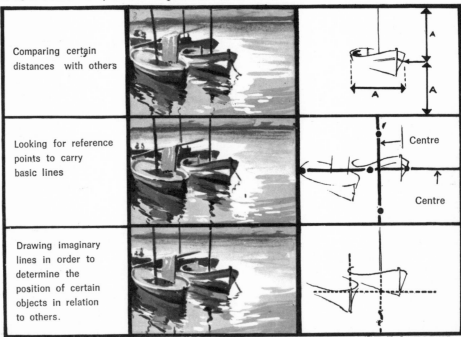

The mental calculation of dimensions consists in:

Comparing certain distances with others

Looking for reference points to carry basic lines

Drawing imaginary lines in order to determine the position of certain objects in relation to others.

How marvellous it would be to see into the mind of this artist, to follow his train of thought and know exactly what he is thinking as he carries out his vital task of observation and measurement. Let's try...

«*Good, this is just the kind of scene Jack wanted for the living room. Simple and easy — a doorway, a balcony and a blind. Not much perspective. Colours? Well, green for the blind, red for the walls, I think. This will look quite good in colour. Doorway, balcony, another balcony and then a bit of roof. Easy. I'll charge him a tenner. I'm sure old Jack, with his engineering works, will agree to that ... after all, he must be worth a bit!*

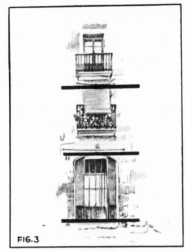

FIG.3

«*Let's see now ... doorway, balcony, balcony ... Are both balconies the same height? No, the top one's a little lower. Influenced by the perspective a bit. Is the doorway the same height as the first balcony? No, it's higher. Hm, I must have a reference point. Doorway, balcony ... I've got it! The doorway is the same height as the balcony with the piece of wall underneath it. That's it. I'll charge him twelve quid.*

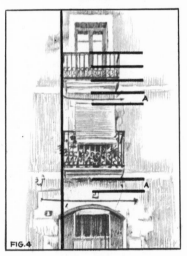

«*From one balcony to the other? It's just half the distance from the top of the doorway to the first balcony, by the number of the house. And that's the same as the distance between the roof and the top balcony ... and then another the same ... and another ... and that's the railings done.*

FIG.4

«*Doorway, balcony, balcony ... that's it. A vertical line ... there! One more line right down, then that's it. Ah, that's better.*

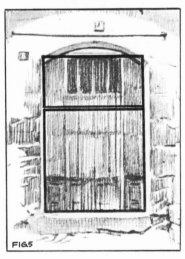

«*Rectangular doorway. What about the height and the width? It's higher than it's wide ... but how much higher? Let's see ... if I make a square first, then put half the square on top ... that's it. «Easy and cheap,» he said. Hm! I'll ask him a leading question about last year's profits and he won't have the nerve to query the price!*

FIG.5

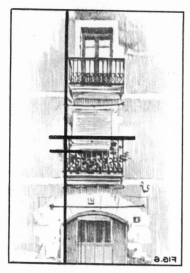

«That whole engineering works must have a pretty hefty turnover. Are both balconies the same width? Yes, and just a little narrower than the doorway. There ... another vertical ... cut it in half and there's the other railing. The end of the blind lower down ... fine! That was simple enough.

«Doorway ... glass panel ... one, two, three, four. Four smaller ones, the same width, in the middle ... there we are, that's the glass panel. Not a penny less than twelve quid. Output up by 15 % last year, was it? Fifteen per cent! Strewth! And I'm charging him twelve quid, I must be out of my mind!»

The artist was making more than one calculation at a time and some of his calculations had nothing to do with dimensions! In all seriousness, though, I think this description of the artist's thought processes has illustrated how to overcome the «white paper barrier».

His approach to his subject showed that, even before he had taken the paper out of his portfolio, he was comparing dimensions, looking for reference points, drawing imaginary lines, positioning blocks and generally studying how he was going to start relating proportions and boxing up.

Can these reference points be found in every subject? Indeed they can. It is always possible — as it was in the case of the façade of the house — to find distances that correspond and can be compared.

You just need to be able to pick out such distances and measure

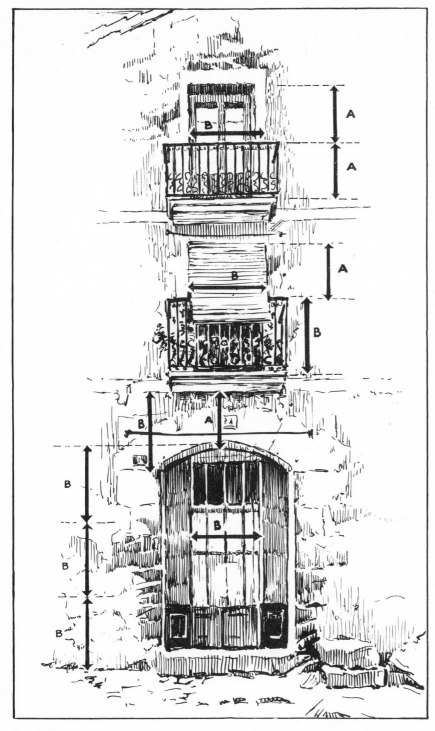

This subject, like nearly all others, contains distances which correspond and can be compared. Illustrating this point, the drawing on the left contains a number of dimensions which can be compared with each other, whether as equals, halves, thirds, quarters, etc.

them by eye, to be able to state that this distance is the same as that distance, or is twice as long, or three times ... and so on.

The easiest way to learn how to calculate distances by eye is to follow Leonardo's advice, as illustrated on the following pages.

As you can see, these exercises are endless and can be tackled in a variety of ways. I shall confine myself to describing a few basic ones in the hope that you will be able to work out others for yourself and, above all, that they will form an important part of your training.

Use large sheets of paper since, the longer the lines you draw, the more difficult it becomes and the more practice you get in calculating distances by eye.

It doesn't matter what kind of paper you use, nor what number pencil. I would, however, suggest that you work at a drawing board, sitting some distance away from it so that your arm is extended and the pencil held well inside your hand.

1. — Draw a horizontal line about 6" long. Then, by eye, divide it in two with a vertical stroke:

2. — Draw a horizontal line about 3" long. Then, still by eye, draw another line the same length beyond it:

3. — Draw another horizontal line about 3" long and, beyond it, another line half the length of the first:

4. — Draw a further horizontal line about 3" long and, beyond it, two vertical lines equalling the length of the horizontal line:

5. — Make a square, drawing its sides in the order shown:

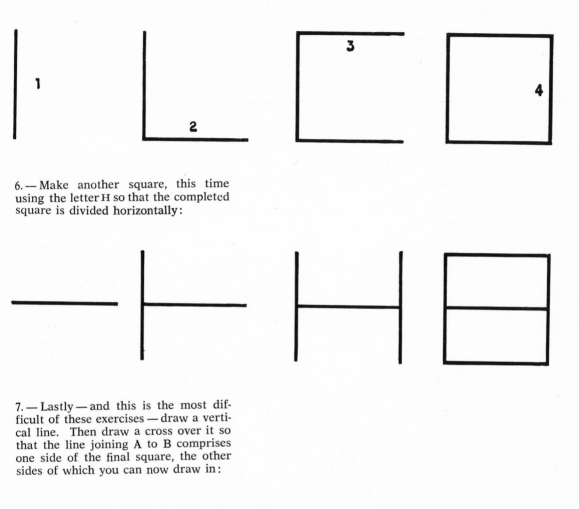

6. — Make another square, this time using the letter H so that the completed square is divided horizontally:

7. — Lastly — and this is the most difficult of these exercises — draw a vertical line. Then draw a cross over it so that the line joining A to B comprises one side of the final square, the other sides of which you can now draw in:

Practise these exercises in the order shown and then check them with a ruler. Very soon you should be able to calculate accurately by eye.

Look at the two drawings of Sir Winston Churchill below. You will see that, in one of them. I have deliberately altered the distance between some of the features — there is an extra 1/8" or so between the eyes, for example, and the nose is about the same amount longer. I have also reduced the distance between the nose and the upper lip.

This is the result of an error of fractions of an inch in the calculation of distances.

The «principal factor in drawing and painting», is, as you can see, very important.

Now look at the lower drawing, in which the features are accurate. This is a real likeness and no-one can say, «Well, yes, it does look like him, but something isn't quite right.»

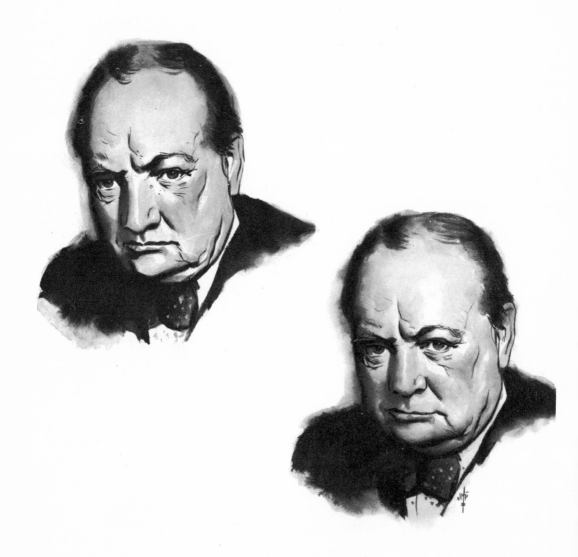

HOW TO RELATE AND MEASURE DISTANCES

Let us return to our friend the artist in front of the old house, although this time we will forget his thoughts about Jack and his engineering works.

He has already taken up his pencil and drawn a few lines. Suddenly he stops, grabs his rubber and rubs out one of the lines.

Then, with his arm extended and holding his pencil upright, he raises the pencil to eye level and slowly moves his thumb upwards, measuring some feature of his subject. When he has got the right measurement he turns his hand and, with his arm still extended, holds the pencil horizontally.

The two boys look on in fascination; then, exchanging bewildered glances, they run off, saying «He really must be out of his head.»

How wrong they are! On the contrary, he is measuring, checking whether his mental calculations were correct, relating, to the last fraction of an inch, the width of the doorway to its height.

This is what you must do, until you have mastered the technique. Try it yourself, comparing the dimensions of two objects in front of you. Although you will see that the artist is using a pencil in the illustrations that follow, it is, in fact, possible, to measure with more or less anything straight that comes to hand, for example a ruler or a paintbrush.

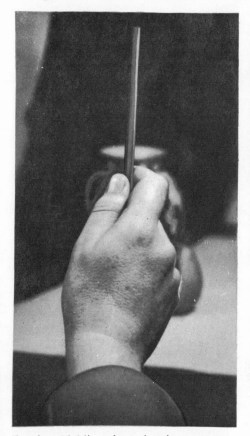

Fig. 9. — Holding the point downwards, take the pencil so that as much of it as possible is visible.

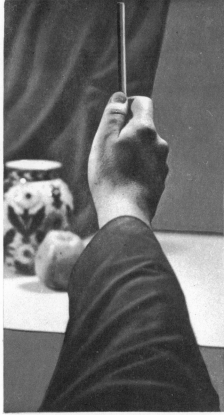

Fig. 10. — Closing your left eye and taking care not to move your body forwards, extend your arm as far as possible in front of your right eye.

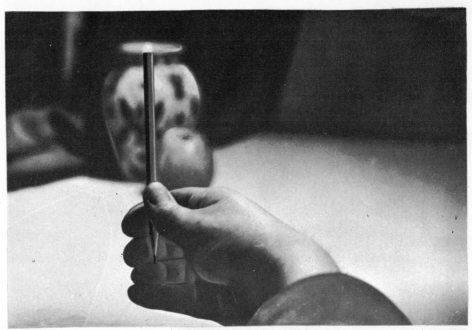

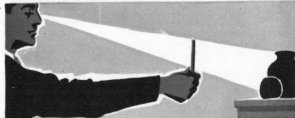

FIGS. 11 and 12. — Hold the pencil in front of one feature of your subject and measure its height by moving your thumb up and down the pencil.

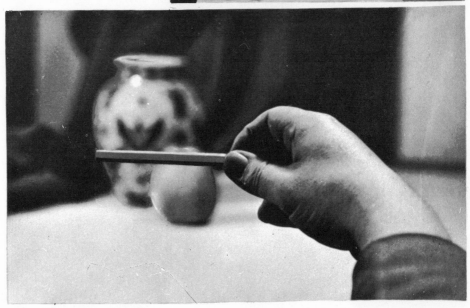

FIG. 13. — Then, without moving the position of your thumb on the pencil, look for another measurement equal to the first. For the sake of accuracy, though, it is important not to bend your arm or move your body.

Our friend the artist is already drawing lines with complete confidence. Now and then he makes use of the measuring pencil, dividing the subject up and making marks on his drawing. He is measuring and relating simultaneously.

WHAT IS SCALING AND HOW IS IT DONE?

> **Scaling is the art of increasing or reducing the forms and dimensions of a given subject while maintaining its correct proportions.**

In other words, scaling means reducing something to a smaller scale while maintaining the differences in size of the various components of the drawing. If, for example, you are drawing a vase and an apple, and the vase is twice the height of the apple, you must keep this same relationship in the drawing.

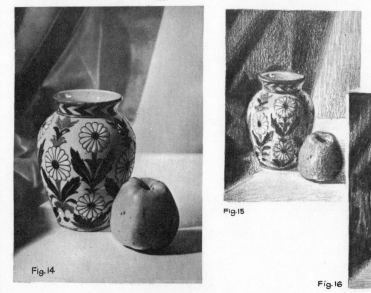

Fig. 14

Fig. 15

Fig. 16

Fig. 14 above shows the subject as it is. Fig. 15 shows the subject rather smaller, while Fig. 16 is obviously out of proportion.

If someone has a very large head, we say that it is out of proportion (i.e. both in relation to the dimensions of his body and to those of a normal head). If you examine a classical Greek statue you will see that the dimensions of the head, bust, arms, legs and other parts of the body all correspond to certain ideal proportions.

So far, so good. Your problems start when it comes to reducing your model to the exact measurement of your paper and, at the same time, keeping everything in proportion. This is the problem our artist is in the process of solving.

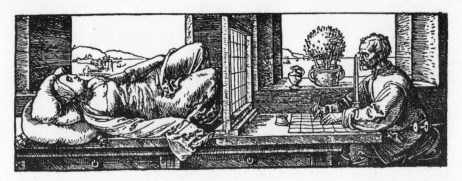

Fig. 17. — Albrecht Dürer drawing with the aid of a squared glass

The great 16th-century draughtsman and painter Albrecht Dürer invented a number of devices for overcoming the problem of the transfer of dimensions and proportions. One such device consisted of a squared glass which he placed in a frame between himself and the model. Then, having drawn the squares of the frame on the paper, he «copied» from the glass with the help of the squares, keeping his eye at a constant distance from the frame (Fig. 17).

Not long ago I saw an ingenious device, not unlike Dürer's, for adjusting while drawing from nature. It consisted of a frame made of two pieces of cardboard crossed by four wires, forming a simple system of squares. The artist drew corresponding squares on his canvas and then, fixing the model visually within the cardboard frame, transferred the image by means of the squares.

I won't go into any more detail here of such devices, since I don't think it is a good idea to make use of them at this early stage. If drawing could be compared with, for example, learning to ride, I think you will agree that the first priority is to learn to ride with a saddle before attempting to ride bareback.

Now let us return to the façade of the old house.

When drawing from nature the first question the artist must ask himself is «How much of the scene should appear in the drawing?»

As soon as you have decided this, you must choose reference points to determine the top and bottom of the drawing, as well as the sides. It is nearly always possible to pick out a projection in the wall, a stone, a loose tile or some other little detail which will serve as a reference point. (Fig. 19, points A and B).

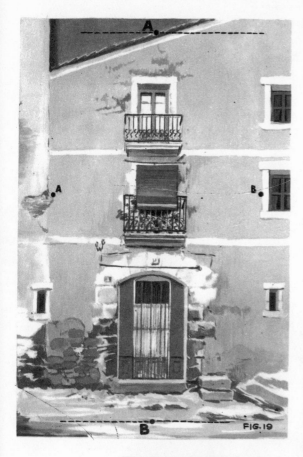

Fig. 19. — Shows what we can actually see, although for our drawing we shall take only the part between points A and B. Then, as the first step in the calculation of dimensions and proportions, we divide the height into two equal parts.

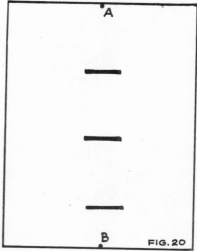

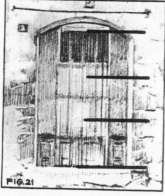

Fig. 21. — The next step is to measure the height of the doorway in order to help us determine its width.

This done, we now have to start measuring with our pencils, dividing the subject into equal parts horizontally and remembering that the arm has to be fully extended and the body kept completely still. Quite straightforward so far, as there are plenty of reference points in this particular subject. It is a good idea always to start off with one obvious measurement, in this case the height of the doorway. Transferring this measurement upwards, as many times as necessary, we discover that the total height of the part of the subject which concerns us is almost three times that of the doorway (Fig. 20).

This will be the first calculation of proportions that we shall transfer to the paper. In order to do this we can use either a strip of paper or the pencil itself, fixing the measurement obtained with the thumb. With practice you will soon be able to calculate dimensions and divide up a given space by eye. This, of course, should be your aim.

Now, continuing the process of calculating the proportions and transferring them to the paper, using the pencil as a measure, it is possible to check whether the width of the doorway is really equal to two-thirds of its height. Then, still by eye, we divide the height of the doorway into three equal parts and determine its width (Fig. 21). And so on...

But there is no point in simply repeating all the artist's mental calculations and arriving at the same conclusions. Just remember that, using the pencil as a measure, you can relate, divide, double and transfer dimensions, using some of the measurements to build up others.

BOXING UP: ENCLOSING IN BOXES AND CUBES

As Fig. 22 shows, you can enclose anything in square or rectangular forms, which we shall call boxes. Anything — figures, stools, houses, oranges, melons, etc.— can be boxed up.

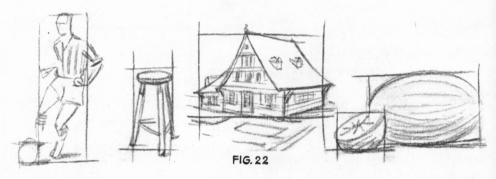

FIG. 22

In addition, every object, form or subject can be «re-boxed up», that is, its component parts enclosed in smaller boxes.

Boxing up does not, however, mean making a box big enough to enclose the whole subject. On the contrary, the artist must be able to use his judgement to make the box small enough to contain just the most important basic lines or forms.

As you can see, the calculation of dimensions is a simple matter once you have drawn the outer box and checked its measurements with the pencil.

Now let us watch the process which follows the boxing up of the balcony of the old house.

The calculations we have already made enable us to determine the position and dimensions of the box which is to hold the balcony.

We then look for a horizontal line as near as possible to the centre of the box and, with the help of the pencil, find one: the bottom of the blind.

We see that the distance between the bottom of the blind and the top of the balcony railings is the same as from point A to point B, which represents the base of the balcony.

By transferring this same measurement to the left-hand side of the box, we can obtain the edge of the blind on that side. From here, using the same measurement, we can draw in the right-hand edge of the blind.

Still using this measurement, we can now position the ironwork and draw in accurately the iron bar above the blind.

How many uprights does the balcony consist of? One, two, three... twelve in all. And the division of a given length into twelve parts is a simple matter after cake-cutting! You first of all divide by two, then each half by three, then halve each resultant width and that's it. All that remains is to fill in details of the surface, the ornamental part of the ironwork and the flowerpots and flowers. Now we're ready to start on the shading.

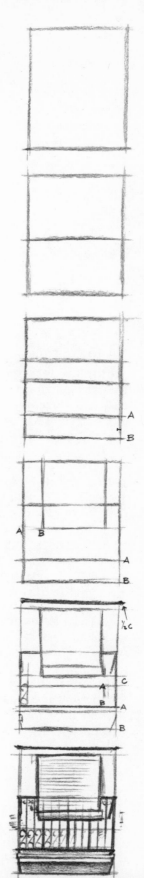

23

THE HARDEST TASK OF ALL

Complex subjects
Elusive dimensions
Fractions of an inch
Unboxable features

We have begun our sight-training practice with an easy subject: the protruding features of the façade of the old house — the doorway and the two balconies — were hardly very pronounced and there was practically no interplay of light and shade. The principal features were of almost geometric simplicity and consisted mainly of straight lines. «Simple and easy» as the artist says.

This was, in fact, the only possible introduction to drawing from nature and it is wise, in the early stages, to stick to straightforward subjects like this, which will help you build up confidence.

Later on, as you gain more practice, you will find yourself tackling more complex subjects, in which, for example, perspective plays a greater part; in which dimensions are not so hard and fast but must, nevertheless, be reproduced with the same accuracy; and in which the principal feature cannot be boxed up in the usual way.

The best example of this is the portrait. In a drawing of the façade of a house, or a tree, or a mountain, or a jug, little errors of dimension will go quite unnoticed. What does it matter, after all, if a door is a fraction too wide or too high? But, as we saw on p. 16, these fractions of an inch matter considerably in a portrait and may alter the whole likeness of the model. How, though, can features so small, but nevertheless so important, as an eye or a lip be boxed up? How can we box in the lines and wrinkles of the skin and the prominence of the cheekbones, all of which depend so much on the interplay of light and shade?

This is the hardest task of all. When you have mastered this you will be able to say with confidence that you have the professional's ability to calculate dimensions and proportions by eye.

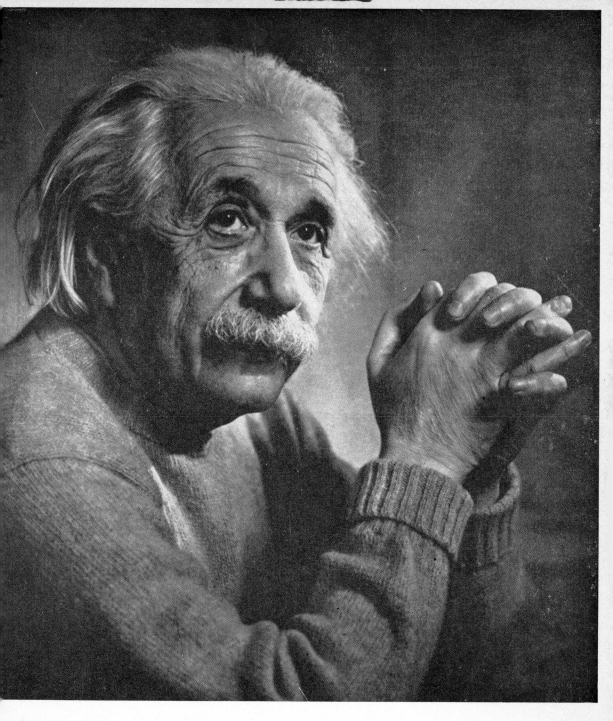

LBERT EINSTEIN

WITH A POSED MODEL

Imagine that Albert Einstein, the great physicist and mathematician who discovered the theory of relativity and is the father of the atomic era, is posing for you. To help your imagination, detach the insert of Einstein from this book and prop it in front of you. I have the picture in front of me as I write.

I suggest that, as a start, you study the process I describe and then try to put it into practice. Although you may not get very satisfactory results at first, you will still have gone through the lessons and will be able to remember and use them when you come to tackle less complicated subjects. That is, after all, what I am trying to teach you.

Ten minutes' observation

The paper, pencil and rubber are all ready in front of you. But you will recall that, before starting anything, you must observe the subject closely, beginning that process of assimilation that will enable you to capture every little detail, in order to be able to produce an exact likeness.

I will think aloud as I study the model: «If I divide the area into four equal parts, the head will be in the top left-hand square and the hands almost in the bottom right-hand square. These are the two principal features. Now I can work out the approximate distance between the head and the right-hand edge of the picture (Fig. 24, A to B) which looks as though it's roughly the same as the total width of the head — although perhaps the head is a little broader.

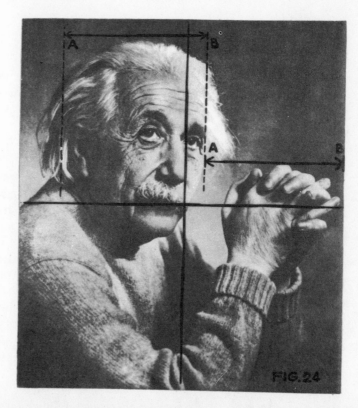

Fig. 24. — The first stage in the mental calculation of distance is to work out a satisfactory formula for dividing up the area. This considerably simplifies the measuring and scaling of proportions and the location of reference points from which to begin boxing up.

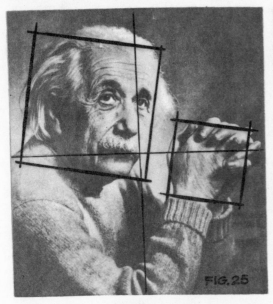

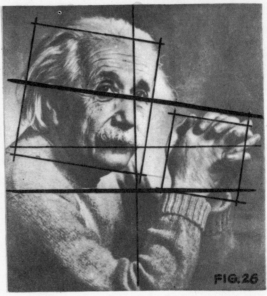

«Next, the head would fit roughly into a square box and so would the hands (Fig. 25).

«Both the head and the hands are inclined slightly to the right so that, if I draw a slightly sloping line at eye level right across the page, it will give me the position of the ear on the left and the tops of the fingers on the right. Then another line, this time horizontal, crossing the page at the level of the seam of Einstein's jersey, will give the position of the cuff (Fig. 26).»

At this stage we shall leave the mental calculation of distances and go on to something equally important:

The search for simplified forms and the
comparison of dimensions among these forms.

The explanation of this is that every subject, however complicated, can be analysed as though it were a jig-saw puzzle. The problem, of course, is to locate and separate the pieces that form the whole.

As you can see in Fig. 27 it is perfectly easy, if you start with basic features and areas of light and shade, to find simple forms that are almost geometric in shape.

If you can analyse these forms as isolated features, you will find it very easy to relate dimensions and proportions. Comparison between your form (as it appears in your drawing) and the real form (as you can see it in your subject) will enable you to rectify, adjust, and, in fact, create an exact likeness.

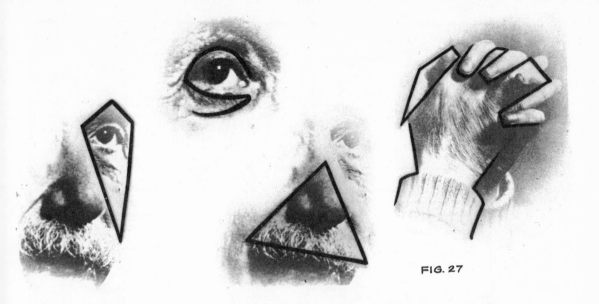

FIG. 27

As an example of this, look at the area of the face around the model's right eye (the eye on the left-hand side as we look at him). Is there not a semi-circle in the combined form of the eye and the eyebrow?

Fine. Imagine that you have already drawn this part of Einstein's face. Then...

if this is **your** semicircle ...

and this is the one on the model ...

you can see that the likeness has eluded you; the drawing is not quite accurate and will have to be corrected until the semi-circle corresponds exactly with that on the model.

The advantage of this system is obvious and can be summed up as follows:

It is easier to calculate and compare dimensions starting with simple forms than with more complicated ones.

Now then, where were we? We had agreed that the preliminary task of observation was over and that we could now begin to draw some lines.

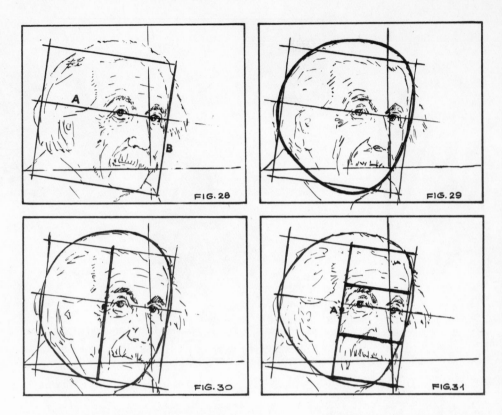

FIG. 28 FIG. 29 FIG. 30 FIG. 31

Division of the space into four squares enables me, with the help of my previous mental calculations, to determine pretty accurately the position and dimensions of the box which is to enclose the head.

What I have done, in fact, is to draw line A at eye level and then line B at right angles to it. These lines determine the inclination of Einstein's head and enable me to complete the box enclosing it (Fig. 28).

Using the pencil to measure with, I then compare the total height of the head with its width and find that the former is greater, since the hair at the top of the head goes beyond the edge of the box. This enables me to draw a rough circle indicating the outline of the head (Fig. 29).

The next step is to find a reference point towards the centre of the head. This presents no difficulty: the left-hand end of the left eyebrow. This is the centre, almost exactly, of the rough circle containing the head. I check it with the pencil and adjust it precisely. Then I draw a new box, inside the first, which will contain the principal features of the face: the eyes, the nose and the mouth (Fig. 30).

Then, in order to determine the approximate position of these features, I measure the height of the forehead and repeat it twice below, thus dividing the face into three parts. It does not matter if they are not exact since the important thing, the determination of the height of the forehead, has been achieved (Fig. 31).

I then draw in the eyebrows, using this line and point A, followed by the eyes. This presents no very great problem since the right eye is contained by its own eyebrow and, according to the rules of anatomy, the eyes must be separated by the width of an eye. The left eye follows straight on.

Then I discover that the length of the nose is equal to the width of the eyes. I draw the outline of the nose and fix the position of the moustache by eye, followed by the corners of the mouth, the point of the chin and the outline of the right-hand side of the face (Fig. 32).

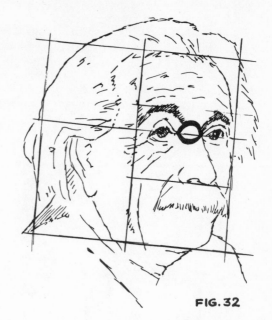

FIG. 32

Hold it!

Before going any further we are going to study and correct what we have done so far. The best method is to look, in the model, for simple shapes in the places that seem most complicated and, like the professional, draw imaginary lines.

Have another look at the full-page insert of Einstein:

In the space between the eyebrows there is a triangle this shape.

The left eye and eyebrow make this shape.

Semi-circle in the right eye.

The rough outline of the nose produces a triangle like this.

The moustache, mouth and chin are contained in this outline.

The inclination of the outline of the right-hand side of the face against the edge of the box produces a triangle this shape. (The adjustment of this outline is very important and, if you follow the instructions, very easy.)

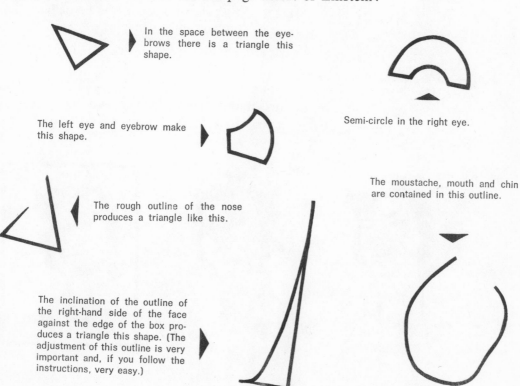

Let's go back to drawing imaginary lines. This is nothing new for, on p. 10, I spoke of «Drawing imaginary lines in order to determine the position of certain objects in relation to others.»

For example, in the figure below the total width of the nose is shown by the two points marked. Two lines drawn downwards from these points will establish the exact position of the low, wide part of the nose.

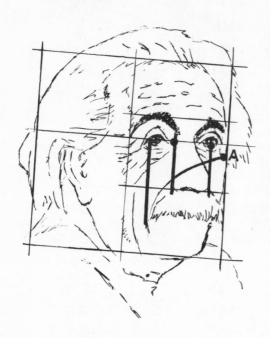

Another imaginary downward line, parallel to the first two, drawn from the left-hand end of the left eye, would fix the position of the corner of the mouth.

All that is necessary to determine the curve of the corner of the mouth is to draw another imaginary line to point A in the figure on the left. Finally, using this system of imaginary lines (which you can, of course, put in on the drawing if you wish) you can check the exact position of the eyes, the eyebrows, the nose and the mouth.

Once the principal features of the face have been adjusted, we can get on to what might be called «the boxing up of masses.»

What are masses?

Before going on to explain «mass», I must explain what is meant by «line» and «tone».

This is line

This is tone

This is mass

It is, I think, unnecessary to explain line. Tone is the intensity of light or shade, isolated or general.

The juxtaposition of areas of different tone defines the «mass».

The masses determine the composition of a work. They are simply blocks of light and shade.

This boxing up by masses is a simple matter. Obviously, *if mass can be described as the scheme of light and shade within the picture as a whole*, then boxing up by masses means the determination of dimensions and proportions starting from the simplification of the interplay of light and shade which exists in the model.

Having cleared up that point, let's get on with the drawing.

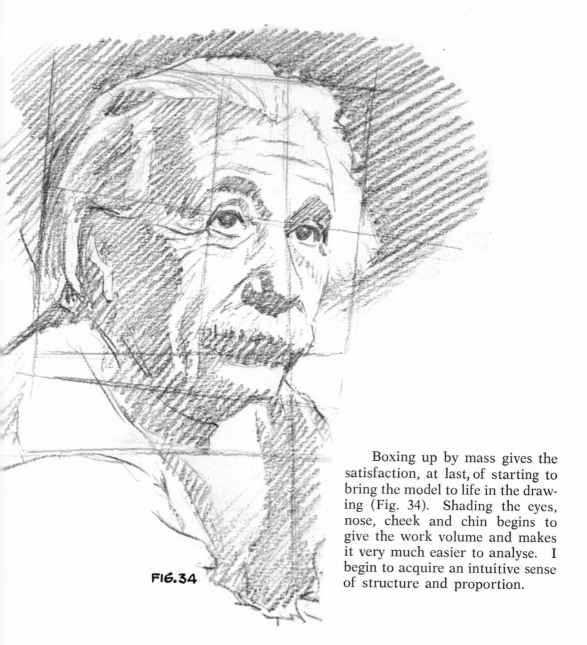

FIG.34

Boxing up by mass gives the satisfaction, at last, of starting to bring the model to life in the drawing (Fig. 34). Shading the eyes, nose, cheek and chin begins to give the work volume and makes it very much easier to analyse. I begin to acquire an intuitive sense of structure and proportion.

The intuitive sense of proportion

If you draw methodically — continually comparing distances, drawing imaginary lines, using points of reference and, in fact, following the suggestions I have made — the time will come when you find you can transfer measurements almost instinctively.

In the early days you seem to be up against a distinct barrier. Proportions refuse to be scaled, one feature is too small in relation to another, a box will turn out to be too big and so on. With practice you will find you can overcome this barrier and that, once this is done, everything is plain sailing.

This is what I call *the intuitive sense of proportion;* it is thanks to this that we can determine distances and measurements increasingly easily as we compare the drawing with the subject.

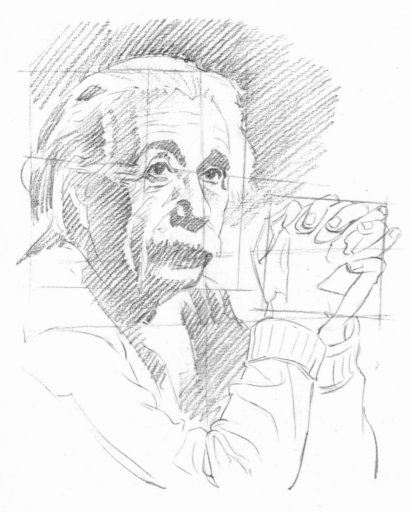

The line drawn at eye level gives me the position of the box which is to contain the hands. Determining the dimensions of this box and its exact position is simply a question of drawing imaginary lines and comparing measurements, transferring those already fixed for the face to the height and width of the hands. Having made a quick sketch of the position of the fingers and the rough shape and outline of the hands, I go on to the familiar task of looking for simplified forms in the structure of the hands.

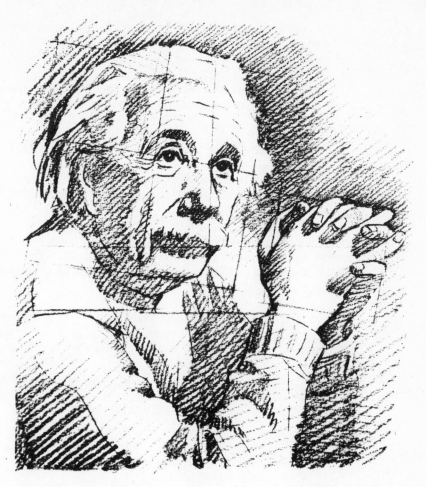

Lastly, following the same routine, I draw the basic lines of the body, box up the shapes according to the masses and so on, as before.

THE LAST STAGE

All ready to begin shading, appraising and building up the final picture?

Not quite. The last and most important stage, which will give us a perfect likeness, is still to come. This is something which does not refer exclusively to portraits: in every drawing, whether it is a figure, a landscape or a still life, there comes a moment towards the end, when you have to stop.

«If you want to be able to discover the errors in your work, you have to give them time to show up» is what Titian used to tell his pupils. And Titian followed his own advice very rigidly. Once he had finished a painting he used to turn it to the wall and not look at it again until, as he put it, «my ego has gone to sleep and I can see things clearly again.»

I am not going to ask this much of you. I will, however, ask you to down tools at this stage and leave your work for a while — until the following day, if possible — when you will return with «a clearer mind and a readier spirit».

After that you must have one last session, as long as possible, comparing distances. You must check the length of everything you have drawn against the model, as follows:

**Place yourself in position, so that, by a rapid movement
of the eyes, you can see both the drawing and the
model without moving your head.**

I cannot emphasize too strongly how important this is.

When you are in a suitable position, look at your drawing and try, for example, to gauge the length of the nose in relation to the space occupied by the eyes.

Look at these parts of the drawing really hard, as though you were trying to commit every aspect to memory. You should then be able to close your eyes and still retain the image, as though it were photographed on your mind.

Then, quickly, look at your model. Try to superimpose the image of your drawing over the relevant features — in this case the eyes and the nose — of your model. See how they compare.

Then back to your drawing... and back to the model... and back to the drawing again... and so on, comparing each feature of the drawing with the corresponding feature of the model.

COMPARING
COMPARING

Comparing and comparing, time and time again, until it becomes an obsession. You are, however, thoroughly enjoying yourself as you gradually impose your will over the drawing and finally conquer it!

This is how that mental itch of artistic inspiration, so hard to explain, begins. It is like a kind of jingling of bells inside you, growing louder until you are smiling for no apparent reason.

How marvellous drawing is!

I usually find myself whistling when I have reached this point. If this happens when I am at home, my wife generally chooses this moment to call the children: «Julia, Philip, quickly! Daddy's ready for lunch, come and sit down!»

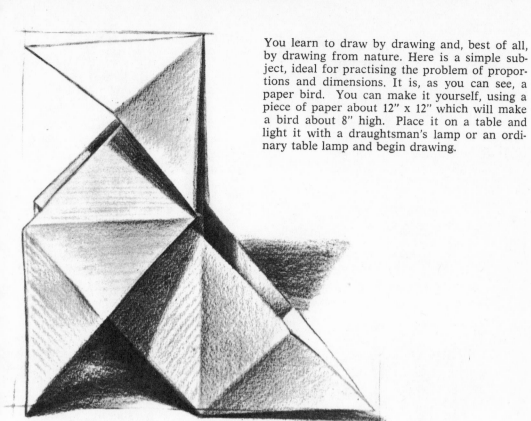

You learn to draw by drawing and, best of all, by drawing from nature. Here is a simple subject, ideal for practising the problem of proportions and dimensions. It is, as you can see, a paper bird. You can make it yourself, using a piece of paper about 12" x 12" which will make a bird about 8" high. Place it on a table and light it with a draughtsman's lamp or an ordinary table lamp and begin drawing.

Start off by drawing it in profile, then in three-quarter position and so on.

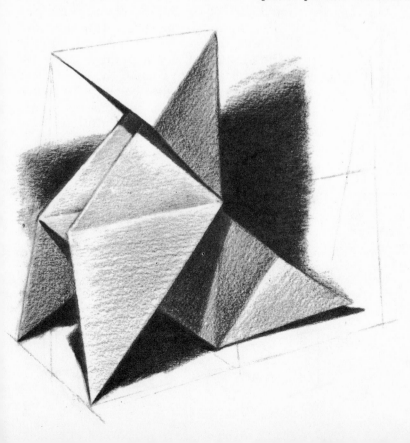

A COMPLETE EXERCISE

This is a practical exercise in drawing a chair. Have you ever tried before? Choose any chair in your house and then follow the instructions below, which hold good for the boxing up of all kinds of chairs, stools, benches and even sofas. As you will see, the problem can be reduced to the following aspects:

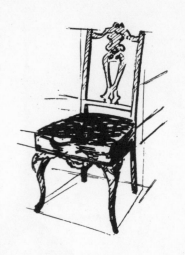

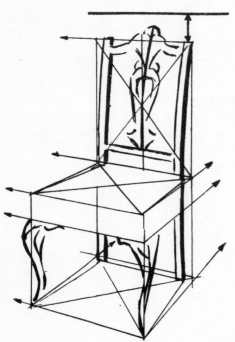

The figure to the left shows the system of lines you have devised for drawing the chair. The three figures below show the sequence to be followed to achieve your objective.

You can see that the first step is the construction of a cube in perspective. Then, if you were to sit for a moment in front of the chair, instead of sideways on, and draw a horizontal line just above its back, you would find, of course, that this line ran parallel to the top of the chair. Having drawn this line, and with the cube already in position, the next step is to draw, above the cube, a rectangle to contain the back of the chair (see centre figure below). This completes the basic outline and enables you to finish the chair without difficulty.

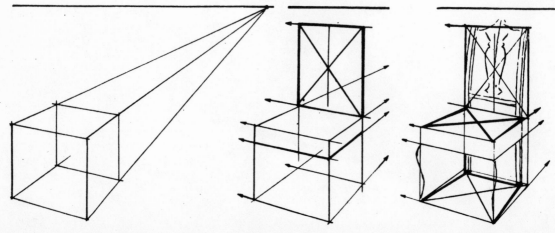

WHEN THE MODEL OBJECTED

*The scene was a life class at the art school. The teacher
taking that afternoon's class was showing the model, who
was new, how he wanted her to stand: «Arm up a bit ...
head a little higher ... right leg a bit further back.»
The thirty or so pupils looked on in silence. Then, while
the teacher was trying to impress us all with his manner,
someone broke the silence by saying «This is just like a
morgue!» We all burst out laughing, more as a release
from the tension than at the remark, which was not
particularly funny.*

*«That'll do!» said the teacher. Then, turning to his model,
he said «That's fine, hold it like that».*

*The model stayed just as she was, standing stiffly to
attention, and we all began drawing. Then, suddenly, after
about five minutes, she got down from the dais in a very
determined way and, without a word, disappeared through the
door at the back.*

*We didn't have to wait long for an explanation. She came
out after a few minutes, fully dressed, and said shakily,
«It's not that I mind standing up there in front of you
stark naked; and I can put up with your cracking
jokes among yourselves! But when you start painting a coffin
and putting me inside it, well, that's the limit and I'm
not going to stand for any more of it ...»*

*«But my dear girl», said Bob, one of my fellow students,
«that's simply the boxing up process. The first stage
is to box up, after which ...»*

*«Well, you're not going to box me up, d'you hear?» and out
she stormed, slamming the door behind her.*

WHY BOX UP AT ALL?

I left the class thinking about the incident that had just taken place and wondering what would have happened if the ending had been different.

«Supposing», I said to myself as I walked down the street, «that the model had asked 'Why box up at all?'

«Bob would probably have answered 'My dear girl, we box up in order to find the proportions and dimensions'.»

Then I think I would have given her an example of what can happen if you don't begin by boxing up.

«Think of an inexperienced amateur trying to draw a figure from life without boxing up. Do you know what he does?

He looks at the face, calculates the dimensions of the head... this wide and this high... and then draws the face. Next he looks at the neck, compares its dimensions with those of the head and proceeds to draw it. He goes on to the bust, calculates that it measures more than the neck and draws it.

He continues in this way until he has completed the whole body. He then stands back and looks at his work and, if he is capable of seeing it at all critically, he realises that the legs are too long or too short and are out of proportion to the rest of the body. Why? Because his errors increased as he progressed. He got the length of the neck slightly wrong and, since he used the neck as the basis for calculating the size of the bust, he got this wrong, too. This, in turn, affected the hips and so on.»

«To sum up,» Bob would probably have concluded, «There was no control over the proportions of the body as a whole.»

A box is:

> a simplified system of measurements and proportions checked against the construction of the subject within it.

This means that:

> in drawing the box, we consider the total measurement of the subject. In drawing the subject inside the box, we check and revise the calculation of dimensions made in the first box.

Let us now imagine the same inexperienced amateur starting out by considering the model as a whole, from head to foot and from one side to the other and drawing the «basket» (as Ingres used to call the box) by comparing its total height with its total width. Then, comparing large distances, he draws certain basic lines within the box; he is still considering the model as a whole and, provided he can continue to see it as such, will then go on to determine the position of the principal features such as the shoulders, the navel, the knees and so on. It is then a comparatively simple matter to start building the body accurately.

SUPPOSING THE PUPIL CAN'T SEE THE BOX?

This is a problem which took me some time to solve.

At that particular time I was teaching some beginners who were encountering great difficulties in drawing from life. Despite the fact that they could all copy drawings und paintings very well — I remember how, on the first day, one of them appeared with a perfect pencil drawing of the head of the film star Charles Laughton — not one of them, when confronted with a real model, was able to choose the basic outlines. There was no point in talking about boxing up: it meant nothing to them.

The night after the incident at the art school I shut myself up in my study with a plaster cast of Michelangelo's Moses and tried to understand what it was that constituted such a barrier between the model and the pupil and prevented him from capturing the basic outline and, therefore, from making any progress at all. Why was it that these pupils were able to copy a drawing perfectly but were defeated by a real model?

I tried to put the clock back to my own amateur days, when I had the same problems, and I finally arrived at a series of conclusions which, I now use in guiding my pupils. There is the world of difference between copying a flat drawing and drawing from life, in which the interplay of dimensions play such a vital part.

Let us now put these ideas into practice.

40

«Foreshortened» is the description of our view of a body placed obliquely or perpendicularly to our level of vision. We speak, for example, of a foreshortened arm when the arm of the model is raised and pointing towards us. Similarly, a figure on a diving board, seen from below, will be foreshortened. A vase or a jug lying on its side on a table is also a foreshortened form.

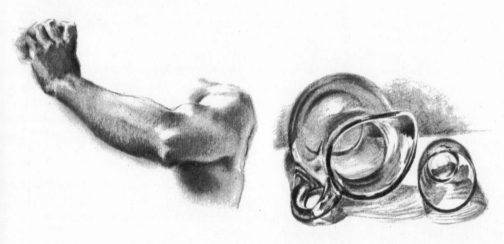

In fact, any body with volume creates an impression of foreshortening: a book, a horse and a woman's head will always have one part or another foreshortened, no matter from which direction they are viewed.

Foreshortening has always been a subject of considerable study and research for artists. Museums and private collections up and down the country contain hundreds of drawings — almost always preliminary studies — of foreshortened hands, feet, arms and heads.

Why all this fuss and bother? Because, quite simply, foreshortening presents more difficulty than almost any other aspect of drawing.

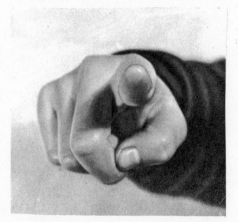

Try for yourself: point at yourself with your right hand, with your forefinger exactly at eye level. Now imagine trying to draw this hand: how will you reproduce the foreshortening of the finger, how will you highlight it so that it is obvious that it is a finger?

This is the next problem after foreshortening.

Let us imagine the same hand reproduced both by an artist and by a sculptor. The sculptor would mould the hand with complete realism, giving it body and volume. In physics terminology we would say that the sculptor is working with the three dimensions existing in all bodies situated in space: height, width and depth. The artist, on the other hand, would reproduce the hand on a flat surface (his paper or canvas) without actually being able to reproduce the sensation of volume; in order to achieve this he would have to draw in all the subtleties of light and shade, thus creating the illusion of relief. In physics terminology again, he would be described as working in two dimensions: height and width.

Now back to your own finger. You have no difficulty in recognizing its position, since you can see it coming straight out of your hand towards you, with the nail in the foreground. Despite its being completely foreshortened, your eye can, in fact, run over its entire length and, at the right distance, can see the three dimensions of all bodies existing in space: height, width and depth.

But haven't we just said that the artist works with only two dimensions and that he cannot reproduce bodies as he sees them in relief? That he works on a flat surface on which the third dimension, depth, does not exist?

This is where the real difficulty begins for the amateur who finds himself in front of a model for the first time. Like you, he has been accustomed, all his life, to seeing in three dimensions. His eyes and his brain are so used to positioning the different parts of a given object at different distances and to seeing everything, in fact, in relief in relation to the objects surrounding it, that even when he looks with one eye only he goes on seeing in relief.

When, therefore, the amateur finds himself confronted with a model, he sees it in three dimensions, which he tries to transfer to his paper; predictably, he finds himself completely at a loss,

unable to reduce to only two dimensions what he sees in three.

Copying a drawing is a straightforward matter, since the problem of three dimensions does not arise. In a drawing the features are flat and there are no problems of foreshortening or of depth — everything can be measured in terms of height and width and it is simply a question of transferring these measurements, with the correct interplay of light and shade, in order to achieve the same results.

BREAKING DOWN THE BARRIERS

If we want to break down the foreshortening barrier and the two-dimensional barrier,

we need to be able to see the model without its third dimension.

That is, we need to be able to see it as a flat object, totally without relief or depth. This involves, obviously, a complete change of outlook on our part, the creation of a new habit.

Is this difficult? Well, yes and no — it depends on how much effort you are prepared to make It is rather like beginning to smoke: in the early stages you have only the occasional cigarette, which makes you cough and sometimes even feel ill. With time and effort, however, you come to master and enjoy it, and it becomes a habit.

It is the same with drawing: the more you draw from life, the sooner it will become a habit. But let me issue a word of warning: if you don't want to start by «coughing», choose models in low relief to begin with and gradually progress to objects with more volume, finally reaching the stage when you are ready to tackle the real stumbling block, complete foreshortening.

I repeat:

begin by choosing objects in low relief

Why do you think it is easier to draw a face in profile than full-face? Because of all the barriers we have been discovering: when you see the model full-face, the nose is completely foreshortened and we have to create its form simply by means of variations of tone. The same applies, though to a lesser extent, to the ears, the cheekbones, the temples and the hair.

The answer, then, is to start off by drawing faces in profile, going gradually on to three-quarter views (semi-profile) and lastly to full-face drawings.

During these early stages, while you are trying to acquire the habit of seeing things flat,

**always choose the aspect of the model with
the least amount of foreshortening.**

In addition, try to forget that the model has volume. Try and see it flat, without its gradations of distance.

Lastly, try and see it as an unknown body.

Don't immediately think for example, «This is a nose» because, if you do, your habit of seeing in three dimensions will instinctively make you «go over» it in these three dimensions and all will be lost. Instead, try and look at it as you would a piece of white paper and think «Here I have an area of tone of this shape and this intensity, while here I have a slightly longer, lighter tone... and so on.» And it's all in the fore-ground!

Think of it like this and it will be just like copying a photograph.

The exercise which follows is designed to help you acquire this habit.

The best way of learning how to see objects without the third dimension is to practise on easy models to start with. This illustration of a spoon, a glass, a plate and a packet of aspirins is a simple and easily arranged still life which would make an excellent practical exercise.

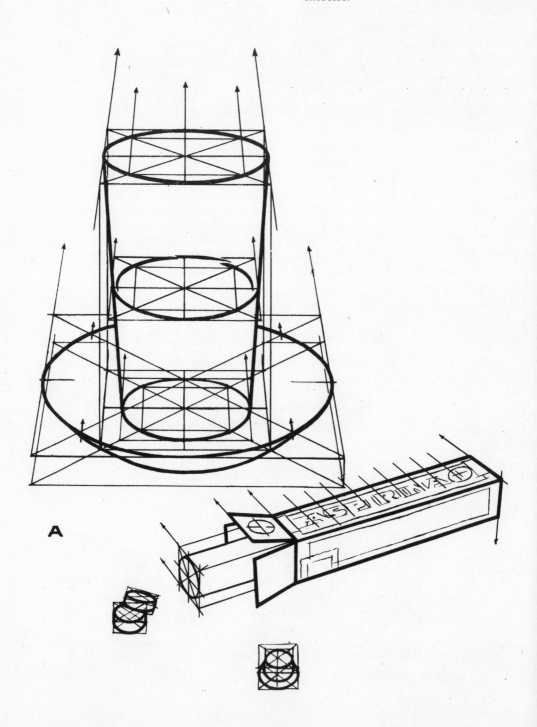

A

As you will see in figure A, the construction of the skeleton of the drawing requires a knowledge of the rules of perspective (1). In figure B, study the direction of the shading and the rather casual execution. This drawing was done with a 2 B pencil.

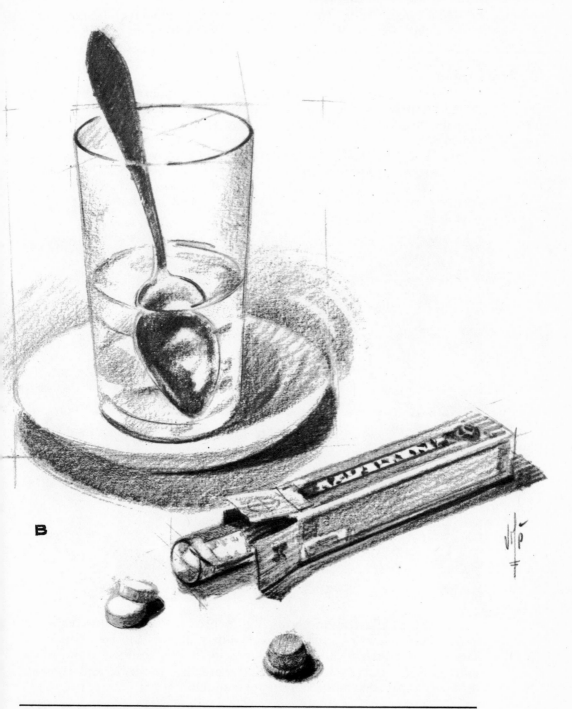

B

(1) You are recommended to read «How to draw in perspective» in the same series as this book. Every aspect of painting and drawing in perspective, including commercial art, is covered.

FROM THEORY TO PRACTICE

THE POSITION OF THE ARTIST IN RELATION TO HIS SUBJECT

When learning to draw from nature it is important to remember, both in the early stages of construction and boxing up and in the later stages of evaluation and the interplay of light and shade, that the artist's whole task depends on a continuous process of observation and comparison.

The efficiency of this comparison depends very largely on the position of the artist in relation to his subject: he must be able to see both his drawing and his subject simply by moving his eyes, if possible without moving his head.

Look at the illustrations below: the first shows the drawing board in the wrong position, since the artist has to raise his head in order to see the subject. The second illustration shows the drawing board in the correct position: the artist can see both the board and the subject without having to move his head.

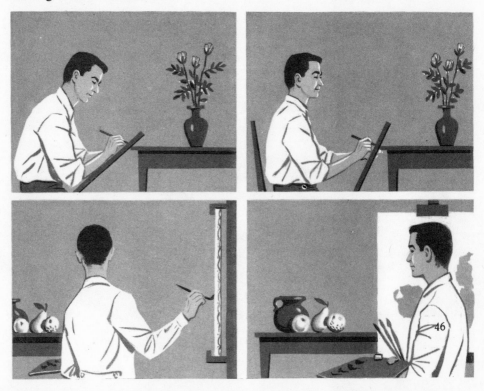

The third illustration shows the incorrect position when using an easel: the artist has to turn through ninety degrees in order to see the subject. The correct position is shown in the fourth illustration, where only a slight movement is required: here he can draw and compare distances «with maximum output for minimum effort.»

Boxes fall into the following three basic categories:

1. — THE FLAT OR TWO-DIMENSIONAL BOX, based on a flat figure and, as we shall see, a kind of all-purpose box.

2. — THE BLOCK OR CUBE, particularly useful for subjects in which perspective plays an important part.

3. — BOXING UP LINES, which can be used both as additions to existing boxes and in their own right.

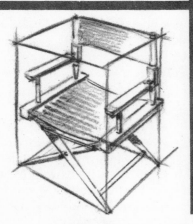

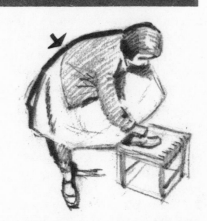

Artists usually work with the flat or two-dimensional box, which can be used with any kind of subject regardless of whether or not perspective is involved. I shall, therefore, devote particular attention to the construction of this box although we should remember, as we shall see, that most of the rules for this box apply equally to the block.

THE FLAT OR TWO-DIMENSIONAL BOX

The first step is to simplify the subject as far as possible so that the principal features can be reduced to a few outlines.

You may remember, at school, studying relief maps of Europe showing all the mountain ranges, rivers and cities as well as the national frontiers. This is the kind of image that professional artists have in mind when they stand in front of their drawing board or canvas: they see the subject exactly as it is, in all its detail.

In your early years at school, however, you may remember seeing simpler, more elementary maps, in which the coastlines and frontiers were reduced to straight lines and the islands were reproduced as little squares or circles.

This is what we might call the box of the other map: a simplification of the same subject.

How is this simplification to be achieved?

STAGE ONE: THE RECTANGULAR BOX

Every subject, however complicated, can be boxed up inside a square or a rectangle.

If this first rectangular box is perfect, it follows that the measurements and proportions it encloses will also be perfect. It is, therefore, important to calculate its measurements very carefully.

First of all we have to decide how much space the drawing will occupy and its position on the paper or canvas. This is straightforward provided we start out with a rectangular box.

The difficulty, however, lies in determining the measurement and proportions of this initial box — a typical problem.

The answer is to try and visualize the subject in a kind of wire frame and consider and compare the height and width of this frame. This, of course, involves seeing the subject without its third dimension.

You know the rule already: take a pencil, a paintbrush or some other similar object in your hand and extend your arm fully so that you can measure one of the parts of the subject — the total width, for example. You then compare this measurement with another — the height, for example. You thus determine the relationship between the width and the height and transfer this calculation to the paper.

This system of calculation is an aid only and should be treated as such. Too much reliance should not be placed on it since a slight movement while passing from one measurement to another — a contraction of the arm or a movement of the body or head — could alter the calculation of dimensions.

You must also calculate by eye, so that you achieve a visual comparison between one measurement and another.

I would also recommend yet again that you practice this sight-training as much as possible. Draw as many of these rectangular boxes as you can, sketching the outline of the subject inside them with basic boxing up lines to check the accuracy of the rectangular box. You should do this by eye, without the help of the measuring pencil.

You should have no difficulty in finding subjects upon which to practice. In your own home, for example, when one of your family sits or lies down, or bends over to do something, you can take up a pencil and paper and draw rectangular boxes, practising the relationship between the width and the height.

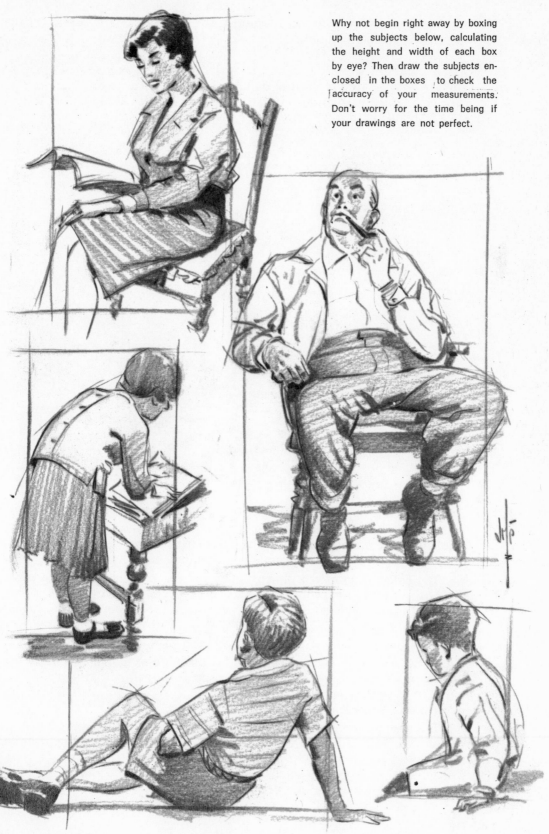

Why not begin right away by boxing up the subjects below, calculating the height and width of each box by eye? Then draw the subjects enclosed in the boxes to check the accuracy of your measurements. Don't worry for the time being if your drawings are not perfect.

A common situation is one in which a subject consists of a main «mass» with certain incidental details around it. This may occur in the case of a figure with an arm outstretched, or holding some object like a stick, a house with a chimney above the roof, and so on.

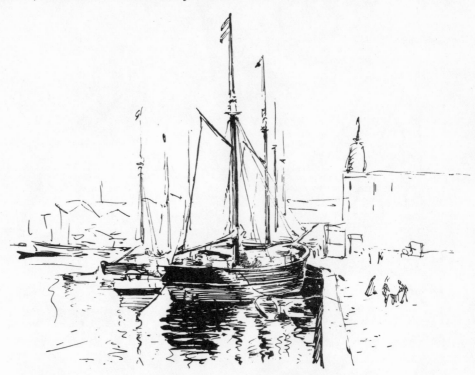

In such cases it is, obviously, the main mass that must be boxed up, with the rest of the subject excluded from the box. Any other procedure would mean complicating the calculation of the dimensions of the rectangular box without giving us any subsequent advantage.

The calculation of the dimension of the parts of the subject outside the box presents no problem since, once the basic box enclosing the principal mass has been determined, the other calculations can be made from this.

This scheme will enable you to achieve, bit by bit, a box which gets tighter and tighter, thus increasing its usefulness. As your boxing up technique improves and becomes more professional, you will place not only the obviously projecting forms outside the box, but also any slight depressions or indentations.

But don't do this until you have had plenty of practice. For the moment you should enclose the whole of the basic form, though omitting, of course, parts which are obviously secondary. After a time you will achieve, almost unconsciously, a more systematic selection of the basic lines and forms of the subject.

We have already drawn the rectangular box, which encloses the basic subject very simply. We will now progress to a rather tighter, more precise scheme of boxing up with such geometrical forms as triangles and quadrilaterals.

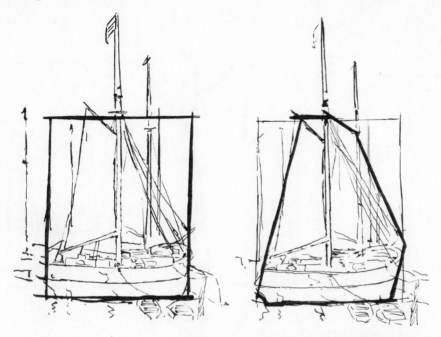

STAGE ONE: THE RECTANGULAR BOX STAGE TWO: FROM THE RECTANGULAR TO
 THE MODIFIED BOX

The professional artist frequently omits stage one and goes straight to stage two, the modified box. His reasons are sometimes that, with his experience, he can imagine the first, rectangular box without having had to draw it and, at other times, that the subject lends itself to a more direct form of boxing up.

You will be able to tell, with practice, which kind of box to start off with. I have purposely discussed the rectangular box first since this logically precedes the modified box.

In order to see this tighter box in your subject, look for one really dominant line upon which you can base the tighter box or boxes. This line may be curved or broken, but try to transform it into a straight one.

Ignore any little details and unevennesses and try to simplify them as much as possible in the interests of achieving a single, straight line.

Then use this line as the basis for all the others, however many boxes you may decide to have.

Dimensions and proportions always require care: if you want to achieve complete accuracy, you must stick to mental calculations, checking each distance with the measuring pencil.

Bear in mind that the new, tighter box is to fit inside the rectangular box; this is where the control of dimensions mentioned earlier is important. If one of the tighter boxes does not fit into the earlier, carefully calculated rectangular box, then one of our calculations must have been wrong.

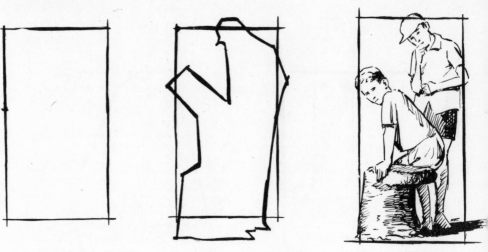

Some readjustment will obviously be necessary in order to give us the correct dimensions and proportions.

Agreed? And does our «basket», as Ingres called it, contain the same proportions as the model? Let's find out.

A FRESH RE-APPRAISAL

We are now going not only to appraise what we have done so far, but also to rub it out — everything, that is, except those parts that will give us some reference to what we have already done, so that we can build up from a few lines which will simplify the subject for us.

STAGE THREE: THE REAL BOX

We have finally arrived at the real box, the one which most closely follows the simplified outline of the model.

It is, of course, impossible to make hard and fast rules for each stage. Each subject has to be tackled according to its individual merits and the artist himself is the only one who can decide which course of action to take. There are, however, some rules that are always applicable and which are summed up opposite.

GENERAL RULES FOR BOXING UP

1. — SIMPLIFY THE SUBJECT BY MEANS OF BROKEN LINES. In some cases one of the dominant outlines of the model may be long and curved and, if this is the case, it is best to study it carefully and draw it first, adapting it as closely as possible to what you see in the subject. But usually the subject's outline will be made up of small angles and tiny curves. It is vitally important to simplify the form by ignoring these little curves and drawing broken lines over the outline in order to form the «basket».

2. — CIRCLES BEGIN IN SQUARES AND OVALS IN RECTANGLES OR QUADRILATERALS. Beware of overdoing the simplification which can be achieved in some subjects by means of broken lines. If the subject contains anything circular, it should — provided it is not too big — be boxed up in a square.

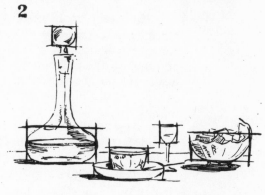

3. — DECIDE ON BASIC OUTLINES AND, WHEN DRAWING BROKEN LINES, DON'T ALWAYS STAY OUTSIDE THE FORM, GOING ALONG THE OUTER SURFACE. Go straight through any little protuberances, just as if you were drawing that elementary map of Europe about which we spoke earlier.

4. — MAKE SURE THAT THE DIMENSION OF EACH LINE IS CORRECT. Don't think, like so many beginners, «I'll correct it later», because you can't build well on bad foundations. Sir Joshua Reynolds once told his pupils, «You will hardly paint very well as artists, if you pay no attention to the form while you are drawing, intending to construct your painting later with the brush». It is essential to build properly from the very first, so that one line can support another and the dimensions of one form can provide a reference point for the construction of others. This, incidentally, is how you can keep a continuous check on what you have already done and control over what you are about to do.

STAGE FOUR: BOXING UP THE FLAT
OR TWO-DIMENSIONAL BOX

We are now going to get «inside the basket.»

An examination of the subject will reveal that it contains certain dominant lines. Many of these will be definite lines, such as — in a figure, for example — that of an arm, the décolletage of a woman's dress, a man's tie, and so on. Others may be created by the interplay of light and shade — and the limits of the shaded areas are often excellent boxing up lines. This is especially true of subjects containing strong contrasts of light and shade.

It is important to remember that our objective is to box up and therefore to simplify, so there is nothing to be achieved by drawing these lines with complete precision. We should treat them in the same way as the ones we drew earlier, following the general boxing up rules on p. 53.

The exact position of the boxing up lines is, of course, important, for it is here that the «likeness» to the model begins to take shape. If you are working on a portrait, for instance, the boxing up line corresponding to the chin could, by its position, give you a longer or shorter head; if you are drawing a woman, the boxing up line determining the breasts would also determine whether you would give the model a high or low bust. While it is, of course, possible to correct such errors at a later stage, perhaps when shading, it is infinitely preferable, as I have already stressed, to do so at once. It is rather like learning a song with a wrong note: the chances are that, when you try to sing the song correctly, you will go on getting it wrong.

THE FINAL STAGE: ANALYSING THE CONSTRUCTION

It is by constantly trying to achieve tighter boxes, by re-boxing up and gradually, while more deeply analysing the construction, getting closer to the final details, that the end of the process is reached.

This is the right moment — when working on a face, for example — for positioning the eyes, the nose and the mouth and — with a still life or landscape — for putting in the non-structural lines.

In order to get a clearer understanding of the phrase «analysing the construction», let us assume that we are drawing a face. We might begin by recalling Ingres' advice:

«The beginning must always be the expression of the end. Everything should be begun in such a way that it can be presented to the public at any stage, showing already that characteristic of 'likeness' that is to be perfected in the end.»

This is easily understandable when you have been subjected to the discipline of an art school, seen how famous artists work and acquired your own experience.

It is advice of this calibre that makes nonsense of inept statements like «Begin at the top and work downwards.» One teacher even proposed that his pupils should do this «in order to avoid soiling the paper by rubbing your hand against the parts you have already drawn!»

The truly artistic drawing is the one which is «finished» at each stage in its development — as an initial sketch, at the outline stage, when it is almost complete and, finally of course, when it is actually finished. It should proceed *not in sections*, but as a whole.

No professional artist will draw one particular feature — say an eye — and stay on it until he has completed it, tackling the whole drawing in this piecemeal fashion. This is the amateur approach. He will take the subject as a whole, so that it gradually evolves from one outline to the next.

This, then, is what is meant by analysing the construction. It does not mean completing one feature before moving on to the next. It means:

Drawing the outlines of the features in their correct positions and with accurate proportions.

The boxes containing the eyes, mouth, nose, and ears in a drawing of a face must all be in position and accurately proportioned so that, following Ingres' advice, the rough likeness can be seen even at this early stage.

SHADING AND BOXING UP

It is advisable, during the process of analysing the construction, to begin shading — in some cases boxing up by means of the shading.

Hold the pencil obliquely to the paper so that the strokes are as broad as possible and start shading. Do not attach too much importance at this stage to the exact size of the shaded areas nor to achieving just the right tone — these details will follow.

This is another process of analysis — this time of the interplay of light and shade. It is a question of seeing whole areas of light and shade, but reducing them to the smallest number of tones — if possible, white, grey and black.

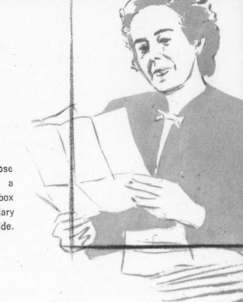

Stage one: enclose the model in a rectangular box leaving the ancillary parts outside.

VISUAL PROCESS OF BOXING UP USING A TWO-DIMENSIONAL BOX

Stage two: in order to be able to draw the modified box, we look for one or more dominant lines in the model (A) which we use to construct the box (B), keeping rigid control over the dimensions and proportions (C and D).

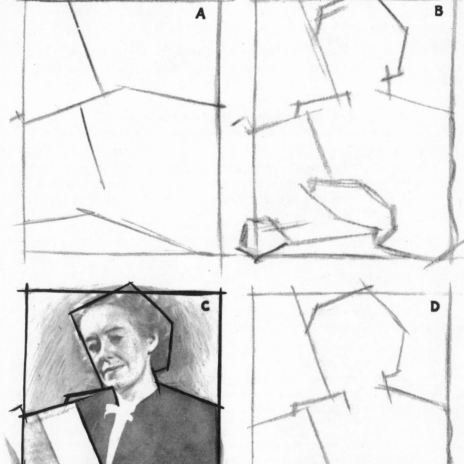

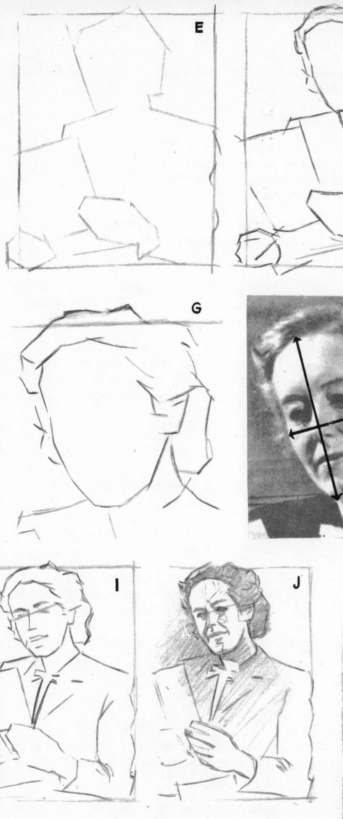

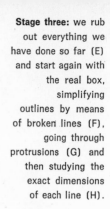

Stage three: we rub out everything we have done so far (E) and start again with the real box, simplifying outlines by means of broken lines (F), going through protrusions (G) and then studying the exact dimensions of each line (H).

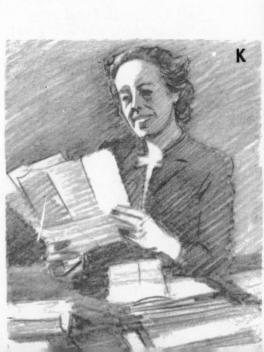

Stage four: we now continue boxing up within the outline, positioning basic lines (I), constructing, in simplified form, the principal features and details (J) and finally adding tone (K).

This does not, however, mean that your shading should be medium grey and completely black.

You should always shade lightly, in a minor key.

You must find an area of shade where the average tone is medium grey so that, when you come to build up the shades definitively at a later stage, there is room for intensification.

You can, naturally, heighten the tonal range within these areas by boxing up the tones in the subject; but take care to do this lightly and carefully.

Boxing up by means of shading enables us to start seeing volume, which gives us a greater understanding of the subject and, consequently, helps us to achieve a more accurate construction.

This completes our boxing up process with the flat or two-dimensional box. We shall discuss the construction of a drawing by means of the block or cube and also say something of the problems of light, shade and atmosphere, although you will study these in more detail at a later stage.

THE MENTAL ATTITUDE OF THE ARTIST WHILE BOXING UP

This is a subject I should like to touch on briefly before going on to the block or cube.

What is going on in the artist's mind while he is boxing up? Does he work quickly, slowly, lightheartedly or what?

It is a sobering thought that, after several days spent planning, consulting and experimenting, it has taken me four hours to explain a process which, in practice, lasts only a matter of ten minutes or so.

This leads me on to the first pre-requisite for successful boxing up and construction:

SPEED

It goes without saying that, before getting on to practical exercises, you must know the rules about holding a pencil, your position in relation to the model and so on. The professional must obviously concentrate on what he is doing rather than how to do it.

He has to draw with light, sure strokes and with considerable mental agility and manual speed and dexterity. This does not mean, as so many many amateurs seem to think, behaving like a kind of juggler. He must

be completely absorbed and carried away by his work; he must work quickly but with precision, combining this speed with the second basic pre-requisite:

MENTAL CALCULATION

As we have seen, the artist must be capable of continuous comparison of measurements and proportions. This must be a constant process, backwards and forwards from drawing to subject.

He must, as I have already said, be capable of shutting everything else out of his mind. Artists sometimes adopt strange poses and find themselves screwing up their faces in order to concentrate better. This is all as an aid to the third and last pre-requisite:

TO SEE AND BE PART OF THE SUBJECT

This means «embracing» the whole subject with your gaze and, at the same time, seeing through it and around it. Ingres was right when he recommended his pupils to «Draw at a distance from the model, making yourselves giants who can dominate and see everything.» In everyday life we are not used to seeing things like this and we have to make a considerable effort to do so when drawing. While drawing one line we must be able to visualise the others; we must see partial volumes and relate them to the total volume; we must continually compare the height and width of the parts we are drawing with the height and width of the whole.

I have rewritten these last paragraphs several times in an effort to explain the artist's state of mind while boxing up; I have done my best to make myself clear. If you follow my instructions and put them into practice, you will not go wrong.

Let me summarize the artist's task:

 a. **Speed.**
 b. **Mental calculation.**
 c. **To see and be part of the subject.**

THE BLOCK OR CUBE

Whenever you come to draw something situated above or below eye level you are confronted with perspective and, with it, the convenience of boxing up using a cube or parallelepiped (a rectangular cube). This occurs in the following cases:

> a. *With objects small enough to be placed on a a table — jugs, glasses, jars, bottles, boxes, books, etc.*
>
> b. *With all medium-sized objects, standing on the ground, whose height is less than that of a human being — chairs and most other furniture, cars, carts, etc.*
>
> c. *With the human figure seen from above or below.*
>
> d. *With bodies in general — even including houses, buildings, monuments, etc. — whose shape is basically a cube or one of the figures, such as a cylinder, cone or sphere, deriving from a cube.*

A figure seen at eye level, on the other hand, is not a suitable subject for boxing up in this way. Nor is a flower — even if it is above or below eye level — since its complex, uneven form will not easily fit into a cube. The same is true of stones, trees, rocks and other similar objects.

PRE-REQUISITE: THE ABILITY TO SEE A CUBE IN ALL BODIES

Do you remember Cézanne's well-known formula: «The trick is to reduce the form of objects to that of a cube, cylinder or sphere»? Do you remember, also, that the drawing of a cube, cylinder or sphere is inextricably bound up with drawing in perspective?

By this stage, providing you have really practised all the exercises, you should have no difficulty in drawing a cube in perspective.

All you need now is to be able to:

See a cube in every body

You should be able to visualize the cube which, like a kind of glass case, encloses the object in question. The cube is a particular shape of rectangular block just as the square is a particular shape of rectangle and, as you start with a square and proceed thence to other geometric shapes, so you can start with a cube and arrive at a cylinder, a cone or a sphere.

These basic shapes are the source of an infinite variety of objects, as can be seen on the opposite page.

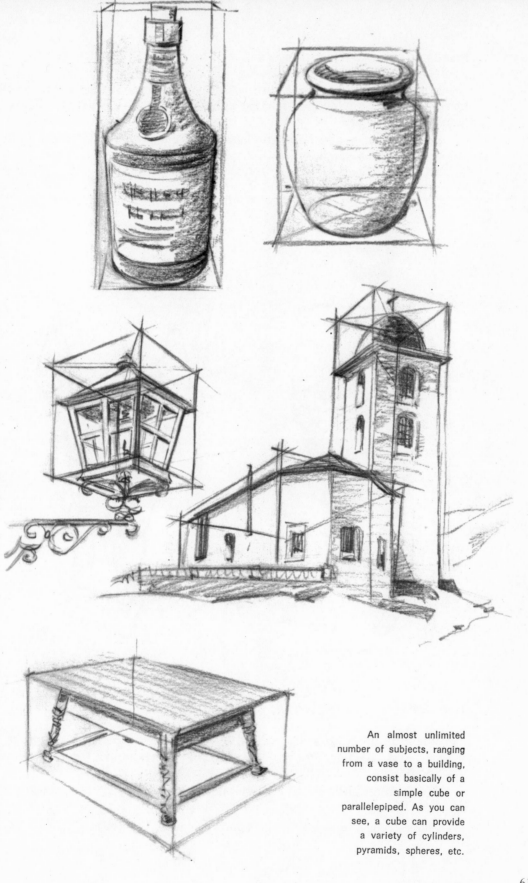

An almost unlimited number of subjects, ranging from a vase to a building, consist basically of a simple cube or parallelepiped. As you can see, a cube can provide a variety of cylinders, pyramids, spheres, etc.

61

Whenever the human figure is drawn from above or below eye level, perspective is involved and the cube or one of its derivatives should be used.

Boxing up in a series of cylinders and circles, considering the whole human body as a series of «articulated cylinders», is also the best way of overcoming the problem of foreshortening.

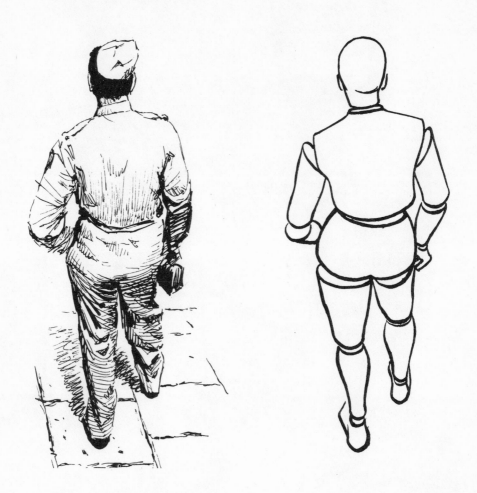

THE IMPORTANCE OF THE «GLASS CUBE» RULE

When building up a drawing with a flat or two-dimensional box, or with a block or cube, you should apply the «glass cube» rule, that is, you should construct the bodies as though they were transparent.

This applies not only to a single model but also to groups of people or a still life containing more than one object, or the interior of a room.

I give three examples on the opposite page.

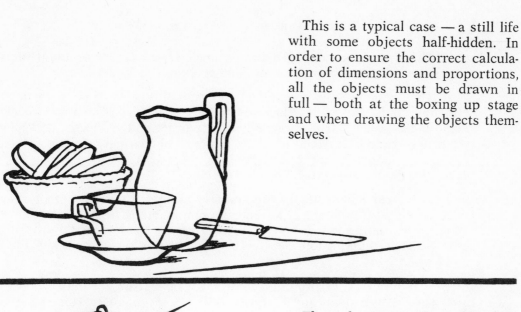

This is a typical case — a still life with some objects half-hidden. In order to ensure the correct calculation of dimensions and proportions, all the objects must be drawn in full — both at the boxing up stage and when drawing the objects themselves.

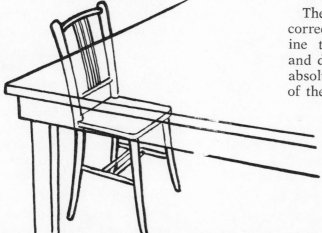

The only way to draw this chair correctly and realistically is to imagine that the table is transparent and draw both table and chair with absolute precision. The hidden parts of the chair can then be rubbed out.

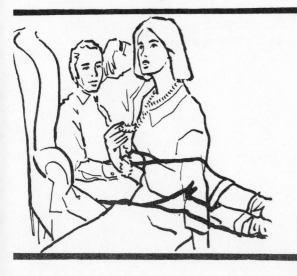

Even when drawing superimposed figures it is best to draw those in the foreground as though they were transparent, thus ensuring perfect proportions for those in the background. A detailed drawing of the hidden parts may not be necessary — this depends on your experience — although it is advisable to draw at least some lines of reference to ensure greater accuracy.

«Know your model before drawing it»

This was the advice of the great French painter Delacroix and it sums up the whole art of constructing and drawing.

This explains why Constable, for example, painted so many East Anglian landscapes; why Claude and Poussin tackled so many classical landscapes; why Murillo was called the painter of the Virgin; and why Dali has produced such a .large number of daringly foreshortened religious figures. They all worked ·at their best when painting the subjects they knew best.

The great eighteenth-century painter George Stubbs is famous for his paintings of horses. I can imagine him standing in front of a horse and, in his mind's eye, removing the flesh from the bones and studying the skeleton, thinking to himself «There is a tendon here, a muscle here...» and so on.

It is this kind of profound knowledge of his subject that produces the specialist painter, in whatever field. Some painters can tackle a variety of subjects with equal ease but most tend to specialize; with time and practice, you will certainly feel drawn more towards some subjects than to others.

Meanwhile, as a general rule, try to really get to know the subject you are going to draw. Look at it not only from the position from which you are going to draw it, but from as many other angles as possible. Absorb its every feature and try to discover how it is made and what it is made of. The American artist Lawson, who was a master of perspective and construction, used to say that, before drawing a stool, you should lift it and try its weight, studying it as though you were going to make an identical copy «composed of rigid feet placed at an angle calculated to give them maximum solidity and firmly joined together at the centre.»

The student who combines his love of drawing with an urge to take his model to pieces will certainly become a great artist. Leonardo da Vinci, not content simply to *see* his models, used to break the law — for at that time it was against the law — by sneaking into the morgue and dissecting the corpses in order to try and achieve a better understanding of the bodies of the living.

DATE DUE